THE

JOY OF

FOREST

BATHING

THE JOY OF FOREST BATHING

Reconnect with Wild Places & Rejuvenate Your Life

Melanie Choukas-Bradley
Illustrations by Lieke van der Vorst

ROCK POINT

Brimming with creative inspiration, how-to projects, and useful information to enrich your everyday life, Quarto Knows is a favorite destination for those pursuing their interests and passions. Visit our site and dig deeper with our books into your area of interest: Quarto Creates, Quarto Cooks, Quarto Homes, Quarto Lives, Quarto Drives, Quarto Explores, Quarto Gifts, or Quarto Kids.

Text © 2018 by Melanie Choukas-Bradley
Illustrations © 2018 by Lieke van der Vorst
Photography © Shutterstock

First published in 2018 by Rock Point,
an imprint of Quarto Publishing Group
142 West 36th Street, 4th Floor
New York, NY 10018 USA
T (212) 779-4972 **F** (212) 779-6058
www.QuartoKnows.com

All rights reserved. No part of this book may be reproduced in any form without written permission of the copyright owners. All images in this book have been reproduced with the knowledge and prior consent of the artists concerned, and no responsibility is accepted by producer, publisher, or printer for any infringement of copyright or otherwise, arising from the contents of this publication. Every effort has been made to ensure that credits accurately comply with information supplied. We apologize for any inaccuracies that may have occurred and will resolve inaccurate or missing information in a subsequent reprinting of the book.

Rock Point titles are also available at discount for retail, wholesale, promotional, and bulk purchase. For details, contact the Special Sales Manager by email at specialsales@quarto.com or by mail at The Quarto Group, Attn: Special Sales Manager, 401 Second Avenue North, Suite 310, Minneapolis, MN 55401 USA.

10 9 8 7 6 5 4 3 2 1

ISBN: 978-1-63106-570-5

Editorial Director: Rage Kindelsperger
Managing Editor: Erin Canning
Associate Editor: Keyla Hernández
Cover and Interior Design: Sami Christianson

Printed in China

For my father, Michael Choukas, Jr.,
a lifelong birder and man of many talents,
who taught me the towhee's song,
"Drink Your Tea."

And in memory of my joyful and
accomplished mother,
Juanita May Crosby Choukas,
whose spirit lives on through her
beloved mayflowers.

CONTENTS

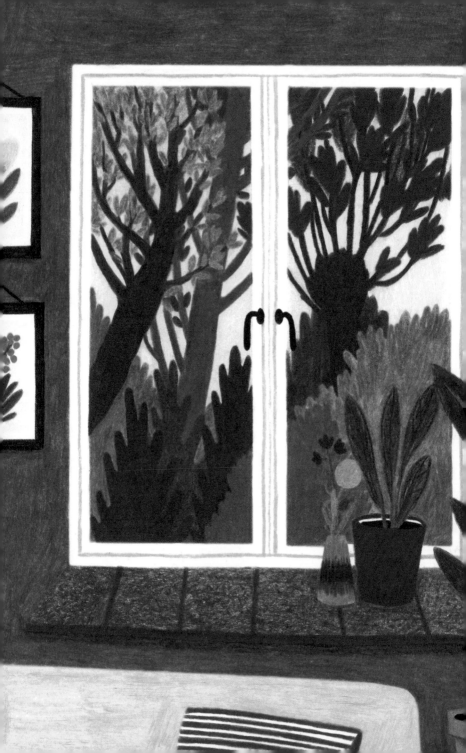

INTRODUCTION

C an you recall a time during childhood when you were fully enthralled by the wonder of nature?

My own memory takes me back to the first time I saw a perfect snowflake. I was walking home from school on a path through the woods when a single snow crystal landed on a flat, dark rock in front of me. Intricately laced and patterned, it was a miniature version of the snowflakes I cut out from folded white paper in school. I knelt down and watched more snowflakes fall from the sky and land on the rock, each one perfect, each one unique, but perhaps none as perfect as the first. Was I in kindergarten, first grade, or second grade? The snowflake memory holds a special place in my mind, connected only to the sky from which the crystals fell and the rock on which they landed.

The dream-like quality of the snowflake memory is much like my other childhood memories of nature enchantment: finding the first woodland wildflowers just after snow melt in the spring; lying on a bed of moss and looking up into the leafy branches of a white birch tree; diving into a cold ocean wave and then burying myself in the warm sand; picking up a fallen maple leaf, deep red in autumn, and bringing it home to iron between two pieces of wax paper. The circumstances of my life at the time don't seem to touch those enchanted memories, although the memories

themselves are rich with colors and vivid recollections of place. Childhood nature memories can easily be called up by a specific fragrance, a sound, a sight, or a general feeling of well-being.

Several years ago one of my natural history field-studies students brought me an article about something called *shinrin-yoku*, or "forest bathing," which, the story said, had originated in Japan. I instantly recognized what the phrase meant and my whole being relaxed into what felt like a full body smile. Forest bathing was defined as full sensory immersion in the beauty and wonder of nature.

I felt grateful to find a name for those moments in nature that had captivated me in childhood and throughout my life, and to learn that people on the other side of the world were engaging in forest bathing as a practice, much like yoga, tai chi, or meditation. I wanted to know all about forest bathing, and I soon found myself on a plane to California to join a North American version of a forest bathing walk. A few months later I began training to become a nature and forest therapy guide so that I could learn how to lead the walks myself.

As a naturalist and author of natural history books, I had been leading nature walks and tree tours in and around

Washington, D.C., for many years. Somewhere along the line I recognized that the times that meant the most to me on those walks were not the ones focused on plant identification. They were the times of collective reverence, when everyone grew quiet, surrendering to the beauty and wonder of the moment. On a traditional nature walk, such moments may occur occasionally. On a forest bathing walk, however, quiet surrender to beauty and wonder is the essence of the experience.

I have now been leading forest bathing walks for several years, and I have visited Japan with a small group of North American forest therapy guides to participate in walks led by Japanese shinrin-yoku guides. The forest bathing experiences I have shared with hundreds of people have convinced me that this practice can bring joy, health, and happiness into anyone's life no matter your age, fitness level, or place of residence.

WE BELONG IN NATURE

Our ancestors had no shopping malls, skyscrapers, factories, cars, planes, or electronics. In the scope of human evolution, these innovations have been around for the blink of an eye. Today's buildings are taller than trees, our planes fly higher than birds, our machines are louder than wind and waterfalls, and our electronics are more enticing than twigs, buds, flowers, and leaves. If we were not so engaged with the innovations of the past two centuries, where would our attention go?

Our agrarian ancestors were engaged with the weather and attuned to the seasons in both pragmatic and celebratory ways. Their medicines, as well as their foods, were gleaned from plants and other natural sources. Many cultures wove elements of nature's beauty into their cooking vessels, homes, and places of worship.

The German language has a wonderful untranslatable term for the feeling of solitude one experiences when alone in the forest: *waldeinsamkeit*. If waldeinsamkeit were translatable, would it prove to be universal and applicable to something that many of our ancestors experienced? Maybe so. After recently learning the word, I discovered that the nineteenth-century American nature philosopher Ralph Waldo Emerson

wrote a poem entitled "Waldeinsamkeit," in which he exalted time spent quietly surrendering to the magnificent beauty of nature.

Many people around the world today remain in close harmony with nature and perhaps you are lucky enough to be among them. The Norwegian term *friluftsliv*, translated as "open-air living," describes the Scandinavian passion for time spent in nature. For those of us who have more or less lost our feelings of closeness with nature, we have only to observe our young siblings, children, or grandchildren and remember our own childhoods to know that engagement with nature is a deeply rewarding pastime and state of mind. In our busy lives, if we can take time out to commune with nature as often as possible, will we not be calmer, healthier, and happier?

BEING IN NATURE IS GOOD FOR US

In 1982, the Forest Agency of Japan began promoting a practice they called *shinrin-yoku*. Stressed and overworked citizens of Tokyo and other cities were encouraged to leave bustling urban areas periodically and spend quiet time in forests as a way to relax and restore mental equilibrium and physical health.

Rooted in the ancient Japanese reverence for nature, shinrin-yoku involves full sensory immersion in the beauty and wonder of nature and trees. Today there are many designated shinrin-yoku forests and trails throughout Japan, and hundreds of thousands of people walk them each year, stopping to enjoy the flowers, commune with the trees, and listen to flowing water.

If you're ever lucky enough to spend time with a shinrin-yoku guide on a designated forest therapy trail, you're unlikely to harbor any doubt that the experience was beneficial to your health. Colorful trailside charts depict many years' worth of cumulative health research on the benefits of forest bathing. Your own blood pressure, heart rate, and other vital signs may be checked before and after the walk.

Dr. Yoshifumi Miyazaki at Chiba University's Center for Environment, Health and Field Sciences and Dr. Qing Li at Nippon Medical School have studied health data collected

in Japanese forests and parks. Their research teams have shown that forest bathing lowers your blood pressure, pulse rate, and cortisol levels; increases heart rate variability (a good thing); and improves mood. The volatile compounds known as phytoncides, which plants generate to protect themselves from pathogens, may even protect human health when they are emitted into the forest air. Dr. Li's studies have shown that when we breathe in these airborne compounds, they appear to boost our immunity to cancer and other diseases by increasing our natural killer (NK) cells. The physical, mental, and emotional health benefits of time spent in nature have been corroborated and augmented by researchers in South Korea, China, the U.K., Europe, and North America.

The phytoncides emitted by large conifers such as cedars and cypresses appear to be especially salubrious, and Japanese forests harbor mature groves of Hinoki cypress and Japanese cedar, or *Cryptomeria* (known as *Sugi* in Japan).

Your own experience is likely to offer compelling validation of the health data. When your guide hands you a silver mat (looking something like a magic carpet) and suggests you lie down under an ancient red-barked Hinoki cypress tree, and you taste rainwater falling into your mouth in occasional droplets from the tall crown of the tree, you will have a pretty good idea that this is not only making you feel good but is probably having a rather positive effect on your health as well.

I experienced many special joys during my forest bathing trip to Japan. As a person who has spent much of her life in pursuit of natural beauty, I was thrilled to be in a country where signs along the highway show enticing woodland scenes and direct you to designated forest therapy bases. The Japanese shinrin-yoku guides—who led our small group of North American guides on forest bathing walks not far from Tokyo and in the Japanese Alps—seemed never to have lost their sense of wonder.

In the Shinano-machi healing forest, north of Nagano, our guides encouraged us to walk in icy water and then splash barefoot in mud; to hug the trees and smell the flowers, fruits, and leaves; to turn hollow plant stalks into whistles; and even to listen to still and flowing water with submerged stethoscopes. And before, during, and after every walk, they touted the health data demonstrating the beneficial effects of nature engagement.

All of our shinrin-yoku guides were well-versed in ecology and the medicinal value of the plants growing in their forests. One had a medical degree and another commuted from a tech job in Tokyo to lead walks on weekends.

The Japanese forest bathing infrastructure is enviable: forest therapy centers set up for naturalist education, health research, and even woodworking and soba noodle-making; specially designed benches along the trail tilted for comfortable day or night sky viewing; trailside tea houses deep in the forest with wood-burning stoves; outdoor yoga platforms; and even a forest therapy train connected to a wheelchair-accessible forest bathing trail.

The ancient Shinto, Buddhist, and folk traditions in Japan foster reverence for nature and lend themselves to the practice of forest bathing. Small Shinto shrines can be found throughout the country, along remote

mountain trails, or tucked between a pachinko parlor and convenience store in the heart of Tokyo. Sacred trees are often enshrined nearby, encircled with a ritual rope and tassels symbolizing purity. Buddhist temples are surrounded by tall trees and carefully tended traditional garden spaces. It is no accident that it is here in a country steeped in an appreciation of nature and the grace of each moment spent communing with it that the practice of forest bathing arose.

But forest bathing doesn't require a trip to Japan and a visit to the idyllic setting of the Japanese Alps. You need only to find a small patch of untouched (or lightly touched) nature to revel in its joys. In this book, I'm going to share what I know about the practice of shinrin-yoku, or forest bathing, which also translates as "soaking up the forest atmosphere." (The terms "forest bathing," "forest therapy," "nature therapy," and "shinrin-yoku" are used synonymously in this book, and refer to the beneficial experience of quiet time spent in nature. The practice also goes by many other names in the native languages of people throughout the world who are discovering its benefits.) I'll describe methods I've learned to help you find increased health and joy in nature. I'll speak from a life spent seeking quiet time in nature and finding solace and joy in field, forest, desert, mountain, and shore. I'll also share my experience as a nature and forest therapy guide trained by the Association of Nature and Forest Therapy Guides and Programs (ANFT) and highlight my time spent in the "healing forests" of Japan.

HOW TO FOREST BATHE

The best place to begin forest bathing is close to home. Perhaps you can find a small patch of earth and trees near where you live or work and adopt it as your "wild home" for forest bathing. A pristine environment with clean air and water is ideal, but if you live in a city or suburb you may have to improvise if you want to weave forest bathing into your life as a regular practice. Your chosen forest bathing spot can be a nearby woodland, a neighborhood park or garden, or even your own backyard. If your neighborhood lacks easy access to green space, you'll have to go a little farther afield. On a forest bathing walk it's not necessary, or even desirable, to cover a lot of ground, so you don't need a large tract of land.

On a three-hour forest bathing walk, for example, I cover no more than a mile—and often less.

If your wild home is close to your indoor home, you will be able to visit your special outdoor spot frequently. However, forest bathing is beneficial even if you only do it occasionally. Studies show that the health benefits last for days or weeks after you leave the natural setting. Ideally, a forest bathing walk lasts for at least two or three hours, but you can practice forest bathing even if you can only spare twenty minutes.

A forest bathing walk has three major parts, and I will guide you through each of them: 1) disengagement from your daily routine; 2) deep breathing and nature connection through a series of quiet activities or "invitations"; and 3) transitioning back to your daily life.

1.

DISENGAGEMENT FROM YOUR DAILY ROUTINE

We are all overworked with lengthy to-do lists. Most of us are dependent on our electronic devices, which afford us convenient ways of connecting with colleagues and loved ones, yet also keep us tethered to our obligations and the often-depressing news of the day. You don't have to leave your phone at home, but you'll find it's best to silence your devices during your forest bathing experience. Think of the airplane-mode setting on your smartphone as "forest bathing-mode." Once you've disengaged and settled into your chosen place, the second and main part of your forest bathing experience can begin.

2.

DEEP BREATHING AND NATURE CONNECTION THROUGH A SERIES OF QUIET ACTIVITIES OR "INVITATIONS"

Draw the air slowly into your lungs as you let your abdomen expand, pause for a few moments, and then exhale slowly. I like to highlight the start of my solo-and group-guided forest bathing walks with a delightful quote from John Muir, the eighteenth- and early-nineteenth-century Scottish-American conservationist and nature philosopher: "Another glorious day, the air as delicious to the lungs as nectar to the tongue."[1] It's amazing how glorious a day becomes once you declare it so and take your first deep breaths of forest, parkland, or backyard air.

Deep breathing not only relaxes you and calms your mind, it also connects you to the life around you. You are breathing in the oxygen produced by the leaves in the trees above you, and you are breathing out the carbon dioxide the trees and other plants require for photosynthesis. As you breathe deeply you'll feel your body relax, and the wonders of your surroundings will begin to reveal themselves.

You can forest bathe as you stand, walk, sit, or lie on the ground. Once you have relaxed into your breath and opened your heart and mind, you will be open to what we, as guides trained by the Association of Nature and Forest Therapy Guides and Programs (ANFT), have learned to call "the pleasures of presence." This exercise is often the first in a series of activities or "invitations" that guides suggest during group forest bathing walks. Standing or sitting in one place, focus on the pleasures of the moment: the way the air feels on your face; the sounds of the wind and the birds and any human-made city sounds; the smells emanating from the earth and trees; all of the visual delights surrounding you. In such moments, you may want to briefly close your eyes. When you open them, pretend that you are seeing the world for the very first time.

After you are relaxed and settled in to your surroundings, you'll find yourself noticing and sensing things that your busy daily self might never perceive or acknowledge. Simply focus your mind on what is moving around you: leaves trembling in the breeze, birds flying through the canopy, a spider positioned in a web, or an ant crawling across the ground. As you mindfully focus on what's in motion in your surroundings, you begin to feel that you are part of all that you see. This sounds simple and obvious, yet the experience is elusive and powerful.

After a time, begin to devise ways to focus using your other senses. Spend time directing your attention to what you hear, both close by and in the distance. You may find yourself especially attuned to particular birdsongs, subtleties of the wind's shifting motion, or the sound of water flowing. In Japan, a shinrin-yoku guide invited us to stand with our backs to a stream, cupping the front of our ears to help focus and magnify the sound without actually looking at its source.

Smell and touch are powerful senses, and plants have many subtle and not so subtle fragrances and a variety of textures. Really get close so that you experience the amazing plants that support your life on earth through the process of photosynthesis, their remarkable ability to turn sunlight and carbon dioxide into food. As you're getting close and personal with plants, you may also become acquainted with their visitors— those that come to drink nectar and gather pollen from the flowers, those that come to dine on the leaves, and those that eat the plant's fruits and spread its seeds!

Learn to recognize nettles, poison oak, poison ivy, and any other plants that could cause discomfort or contact dermatitis so that you'll have no fear of the plants that you touch and smell. You can do a little research online to pull up images of plants in your area that you don't want to touch with bare hands.

If there is a body of water along your forest bathing route, notice the way the water flows, what is reflected in it, and any life that lives in, above, or around it. Tune in to its soothing sounds. If the water is clean, you may want to plunge your hands into it or take off your shoes (or don water shoes) and wade in. Perhaps there is a spring clean enough to drink from on your forest bathing route. Be sure to verify that spring water is potable before drinking. In only rare instances, such as in the mountain forests of Japan's Yakushima Island, is unfiltered stream water safe to drink.

At some point on your forest bathing walk you may find yourself drawn to stones or shells. Try holding them and examining them, getting to know them both with eyes open and shut. I love the weight of a stone in my hands, and enjoy the way it feels as I hold it out in front of me and then over my head. I also like to touch a stone to my face and forehead. If anything is troubling me, I may imagine that I am asking the stone to take and hold my worries.

One of the most rewarding parts of a forest bathing walk is communion with a tree. If you are in a desert setting, you can commune with a cactus (although perhaps not with a hug!), a rock, or another desert feature that you are drawn to. If you are on the beach, perhaps some driftwood or a dune plant will draw your attention. You can use your sense of intuition to locate the tree or other feature you wish to commune with. You may find yourself inexplicably drawn in a certain direction or toward a particular tree. Let yourself be guided.

Once you have found your tree or other natural feature, spend time with it. Commune with it in any fashion that seems comfortable for you. If it's a tree, sit with your back to it, lie down under it and look up, climb into it, give it the proverbial hug, or do all of the above. You may want to speak aloud to your tree, or speak silently, and then "listen" to the tree. Getting to know a tree, and then having a relationship with that tree over time—if it grows near you—is one of the most powerful nature connections a person can have. If this sort of experience is new to you, you may feel self-conscious at first, but that self-consciousness is apt to melt away when you spend time in the company of a tree!

During your forest bathing walk, use your imagination to devise your own unique ways of connecting to the natural world around you. Let the forest speak to you through your heart, mind, and all your senses. You may feel joyful, playful, or contemplative as you respond to the natural beauty around you. You may at times even find yourself gripped by inexplicable sadness. Allow yourself the freedom to respond to your surroundings and the emotions and memories the experience evokes. Nature stirs up a lot in us!

In many parts of the world, the second part of a guided forest bathing walk concludes with some solo time spent sitting or lying on the ground and quietly soaking up the beauty and wonder of the surroundings—earth, sky, trees, and other natural features. At this point, you may be amazed by how comfortable it feels to just sit or lie on the ground, in quiet harmony with the world around you. You may notice that the birds and animals grow comfortable with your presence. If you have adopted a wild home for forest bathing, your intimacy with the plants and animals will grow over time as you get to know the place through seasonal changes, at different times of day, and in varying types of weather. After spending time communing with your surroundings, the third part of your forest bathing walk can begin.

3.

TRANSITIONING BACK TO YOUR DAILY LIFE

This part of the forest bathing walk is the time to incorporate what you have experienced in a bodily and spiritual way in order to help transition back to your daily life. If you're forest bathing alone, simply enjoying a cup of tea and a snack can help you do so. You might also like to sing, recite or read a favorite passage, or write a haiku, short poem, or song of your own. Sitting still by yourself for a few minutes can be the perfect meditative conclusion to a forest bathing walk.

After each group forest bathing walk activity or invitation (such as "pleasures of presence" and "communion with a tree") and at the conclusion of each walk, many forest bathing guides ask people to form a circle and share their experiences with a talking stick. The talking stick can be an actual stick or an acorn, cone, winged seed, feather, or stone—anything found in the circle—and the person holding it has the floor, or more aptly, the ground. I bring portable tripod stools for all my forest bathing participants so that we can sit comfortably in a circle for sharing. I then ask them to focus their thoughts on a topic that can be either loosely or closely related to the previous activity or invitation.

In the circle, I often invite people to share something they feel grateful for right in that moment. Participants can share while they hold the talking stick or silently pass it along to the person sitting or standing next to them. When you hear others express their feelings of gratitude and other forest experiences, it enhances and expands your own experience.

Since most of the activities on guided walks involve a silent, solitary experience in nature—such as noticing what's in motion, communing with a tree, or finding a natural treasure—the reflections and observations that participants make come from a deeply personal place. There is no small talk or cross talk, just a collective sharing from the heart.

The talking stick is something you can improvise on forest bathing walks with your family and friends. It invites a deeper level of communication, infused with the joy of being in the forest together. It also allows for conversation about experiences that we often keep to ourselves because they may seem too esoteric for ordinary discourse.

In Japan, forest bathing guides invite group participation in meditative collective activities such as wood-working

and soba noodle-making. It's less direct than the talking stick activity, yet it provides a communal experience connected to the joy of being in the forest and offers a chance to share and communicate about a meaningful related activity.

Guided forest bathing walks everywhere in the world seem to share a common theme at or near their conclusion: tea. In Japan, wild-crafted teas are served on most walks. On a walk in the Japanese Alps our guides served tea in an open-air wooden structure next to a pond. One of the wild-crafted plants that went into the tea was a close relative of the North American spicebush, which can also be used to make tea. Along with the tea, our guides offered us fruits, wild chestnuts, and pickled Japanese root vegetables in charming handmade leaf cups.

Many forest bathing guides, who are trained to identify a plant thoroughly and definitively before steeping it, bring thermoses of hot water or Sterno cookers in their backpacks so they can make tea from plants collected along the trail. I often serve pure maple sap, either hot or cold, in cups crafted from Japanese cedar, which I purchased on Yakushima Island. I also pass around pure maple candies and walnuts.

If you would like to try making wild-crafted teas, be certain you know the plants you collect thoroughly enough not to confuse them with anything poisonous, and also make sure that collecting small handfuls is allowed in the forest or park where you are walking. Take only what you need for tea.

While serving tea at the close of my forest bathing walks, I ask people to read some of my favorite nature poems: "Wild Geese" and "When I Am Among the Trees" by Mary Oliver [2] and "The Peace of Wild Things" by Wendell Berry.[3] I also love to share quotations from John Muir: "I only went out for a walk, and finally concluded to stay out till sundown, for going out, I found, was really going in,"[4] and "In every walk with nature one receives far more than he seeks."[5] You may have your own favorite nature passages that will enhance the close of your forest bathing walks.

It's very important to create a bridge between your forest bathing experience and your return to the everyday world. I find that people often feel reluctant to leave the forest and let go of the deeply peaceful state they are in. After tea and poetry, I invite a last round with the talking stick, asking participants, "What are you going to bring back to the world with you?" This question inspires people to contemplate ways they can incorporate the peace and joy they've found in the forest into their daily activities as a way of enriching their own lives and the world around them.

A bell can be a simple yet powerful tool to help transition between activities or invitations and as your final transition to the everyday world. I bring a small Himalayan singing bowl and I ring it to welcome people to the forest and then to introduce each invitation and sharing circle. When I sound the singing bowl at the end of a forest bathing walk, it invites a peaceful return to the world.

FOREST BATHING:
WITH OR WITHOUT A GUIDE

Although I am now a certified nature and forest therapy guide, I have been "forest bathing" since I was a child, although I didn't have a name for the practice. I have always found the experience of wandering through the woods or fields to be inherently rejuvenating and therapeutic, allowing my daily concerns to fall away. Solitary forest bathing offers profound joys, as does forest bathing with a small group of family or friends—provided they are willing to set aside normal conversation about the cares and affairs of the day to focus on the beauty and wonder of the natural setting.

If you would like to participate in a guided forest bathing walk, I recommend doing a little research to make sure your guide has had some training in the practice or comes highly recommended by friends or previous walk participants. Japanese shinrin-yoku guides train for about a year and also train guides from other parts of Asia and

Europe. South Korean guides have extensive experience in forest therapy, which is called *sanlimyok* in Korean. Other countries are also developing their own forest therapy certification programs. Guides certified by the Association of Nature and Forest Therapy Guides and Programs attend a weeklong intensive training session followed by a six-month practicum guided by an experienced mentor. At the time this book was written, there were certified forest therapy guides in twenty-four countries on six continents.

Forest bathing will evolve with many variations that other practices, such as yoga and meditation, have done as they've been adopted by different people and cultures. A simple internet search can help you locate forest bathing guides in your area, as well as parks, spas, and nature retreat centers that offer the practice. You may be surprised by the forest bathing opportunities that have sprung up close to home!

WHAT TO WEAR AND BRING ON A FOREST BATHING WALK

It's important that you are comfortable and safe on your forest bathing walks. Dress in layers for the weather and wear loose, comfortable clothing and walking shoes or boots. In some settings—such as the beach—you may be able to wear sandals, flip-flops, or go barefoot, but on most forest bathing walks you'll want to wear sturdy footwear with good soles. There may be times during the walk when your guide encourages you to take off your shoes, or if you are solo forest bathing, you may want to do so. Walking barefoot on the earth is both enjoyable and therapeutic.

Dress more warmly than you would for a hike, as you'll be moving slowly and doing some sitting. Bring rain gear depending on the forecast. Be aware if thunderstorms or other threatening weather conditions are likely and plan accordingly. Wear sunscreen and a hat or carry a parasol. If you live in an area with disease-carrying ticks and/or biting insects, you'll probably want to wear a bug spray (either conventional or herbal) and check yourself carefully for ticks after your walk. Bring water, snacks, and supplies for tea. You may want to carry something to sit on, either a blanket or pad or a portable stool. You may also want to bring a mat to lie on under a tree.

A hand lens or magnifying glass is nice to have on hand for looking closely at flowers, insects, snowflakes, and other natural features. I use a lens with 10x magnification.

If you have a guide, he or she should be familiar with any natural hazards and give you guidance on how to avoid them and stay safe. If you are forest bathing alone or with friends, that's your responsibility. You may want to bring a cell phone, but it's best to turn it off during your walk as unplugging from electronics is one of the mental-health benefits of a forest bathing walk.

Choose a place to forest bathe that is reasonably safe from crime and do not leave visible valuables in your car during your walk. If you are forest bathing alone, trust your instincts and take action if you feel unsafe. Let someone know of your whereabouts before the walk. Bring a map and a whistle as well as a flashlight if you will be out late in the day. A small first-aid kit is a good idea.

I hope you have a grove of trees or patch of greenspace near your home so that you will be able to weave forest bathing into your daily life. If you have to go farther afield, I encourage you to practice forest bathing whenever and wherever you can. The time you spend unplugging from electronics, slowing down, breathing deeply, and engaging all your senses in natural beauty will enhance your health and bring joy to your life.

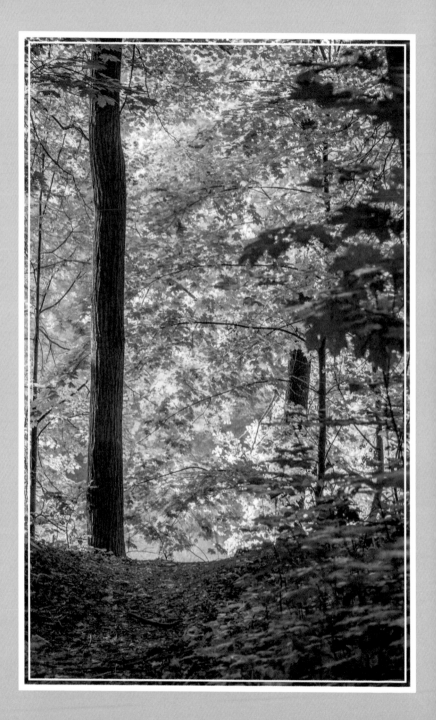

FOREST BATHING WALK

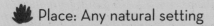 Place: Any natural setting

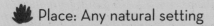 Duration: 20 minutes to 3 + hours

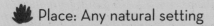 Sequence: Disengage, breathe
deeply, engage your senses, and
transition back to daily life

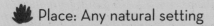 Activities: "Pleasures of presence,"
commune with a tree, tea, and poetry

FOREST BATHING THROUGH THE SEASONS

WINTER

This morning I awoke to a light powdery snowfall. Small icicles hang from our south-facing roofline and starry crystals blanket the skylight in our sunroom. Snow dusts the bare branches of the gingko tree and the evergreen Leyland cypresses outside our windows. Songbirds flock to the feeder in the backyard whenever the plump gray squirrels give them an opening. The sun is still behind the clouds, keeping our world cocooned, and every now and then a breeze sends some of the snow on the cypress branches flying. I'm doing a bit of forest bathing from my desk today!

Last evening I walked along the wild, wooded stream valley winding through my city. The ground was bare but the creek's shorelines were lined with white ribbons of ice. How transformed the woodland scene will be when I go back later today.

I love to forest bathe along this wooded creek, my "wild home," on winter days during twilight when I'm apt to hear the haunting calls of owls echoing in the stream valley. I pinch myself as a reminder that, as I'm strolling under the tall trees listening to owls call, I'm smack dab in the middle of the city.

Forest bathing during winter yields many special joys of the season and it goes without saying that if you live in a cold climate you must dress for the occasion. Bundled up, you can comfortably enjoy the constantly evolving aspects of winter landscapes and winter light. Since you move slowly on forest bathing walks, you'll want to wear an extra layer, or punctuate your winter forest bathing with faster walking.

When the last leaves fly in autumn, the landscape suddenly opens up to reveal new vistas and the architecture of winter trees. The ground is carpeted with the newly fallen leaves, which retain their form for a time, before beginning to break down into living soil. When the first snow of the season falls, the trees, rocks, fences, bridges, and other features of the landscape stand out in sharp relief and you may feel as if you've donned a new pair of glasses. It's a good time to close your eyes during these "pleasures of presence," and when you open them, imagine you are seeing the world for the very first time.

Forest bathing is a joy before, during, and after snowfalls (except perhaps in blizzards!), and no two snowfalls are ever the same. When ice forms on ponds, lakes, rivers, and streams it may remain in place until a dramatic break-up in spring—such as the one described by Henry David Thoreau at Walden Pond—or bodies of water may

freeze and thaw many times. The winter dance of water and ice is one of my favorite things. The sounds of water flowing through ice or lapping in wavelets against it are infinitely variable and melodic . . . ice music!

For anyone with an eye for art or geometry, the endless shapes of ice and snow crystals offer validation for both the patterned order and artistry of the universe. These can seem even more amazing through a hand lens. And wherever you live, this season offers up its own treasure trove of sights, sounds, and—especially on warmer days or in warmer climes—smells.

Winter trees are especially alluring when you forest bathe among them. Forests of snow-clad conifers are most easily explored on snow shoes, ice skates—if you live where the waters freeze deeply—or cross-country skis. You can glide on skis through the blue shadows cast by the spruces, firs, and pines, listening to the wind in their branches.

There are also many pleasures of forest bathing in mixed or deciduous forests, parks, or your own backyard. Leafless winter trees—with their bare crowns and varying textures and colors of bark—invite endless contemplation and appreciation. The bark of American, European, and Asian beech trees is smooth and gray. Plane trees, including North American sycamores, have whitened upper limbs.

Many ash trees have thick bark with diamond-shaped grooves, and oaks have bark that varies from thin and shaggy to thick and deeply grooved. The bark of the trees in your home forest is apt to be varied and distinctive, and it will change depending on the light and whether the trees are wet with rain or dusted by snow.

Tree identification may not be your thing, but you can fully appreciate trees on forest bathing walks without ever knowing their names—or by making up your own names for them. It's fun to contemplate trees' winter features as a part of really tuning into them. If you have a bit of naturalist education, you may know that deciduous trees can be identified in winter by many features in addition to their bark and overall shape. When a leaf falls from a twig in autumn, its stem leaves a mark on the twig known as a leaf scar. Both the placement of the leaf scar—whether it is opposite another leaf scar or part of an alternate arrangement—and the shape of the leaf scar offer clues to the tree's identity.

Even more fascinating and revealing are the buds of the tree. Woody plants, which include trees and shrubs, form their buds during the previous summer when the plant is rich with the season's manufactured sugars and has energy to spare. These buds form both at or near the end of the twigs and also just above where the leaf stalks attach to the twigs.

The buds remain on the trees through the fall and winter, waiting until spring to burst open at budbreak.

Winter buds embody the hope of renewed life. They contain all the tree's new growth—leaves, flowers, and twigs— in embryonic condition. That they can withstand crushing winter winds and storms and frigid temperatures is nothing short of miraculous. And for the winter forest bather with an eye for buds, the rewards are endless.

Each woody plant species bears buds with their own distinctive shape, color, and texture. In my wild home, the shrubby layer of the canopy includes spicebush, which is related to a plant from which the Japanese shinrin-yoku guides make their tea, and pawpaw, which bears fruit relished by wildlife and people alike. The spicebush twig—which smells sharply and deliciously spicy if you scratch a tiny part of its surface—bears small, round, greenish-yellow flower buds that will open into frothy yellow flowers in the early spring. The pawpaw has furry maroon-colored buds. Pawpaw leaf buds look like tiny paint brushes— which have been called "Audubon's paintbrushes" because the famous painter of birdlife is rumored to have used them—and the round flower buds are as fuzzy as kittens' paws.

Winter tree buds are fascinating if you take the time to look closely. The bud of our native tulip-tree looks like a duck's bill, and when I crack one open in the dead of

winter I find tiny tulip-shaped leaves folded up inside. The bud of a bitternut hickory is shaped like a crescent moon and is the color of mustard, while the bud of its cousin, the mockernut hickory, is large, egg-shaped, and a lovely buff color. The delicate twigs of the river birches along the creek near my home bear small, graceful catkins at their tips, representing the tree's male flowers in embryonic condition. Any birches in your woodlands bear winter catkins too. Birch catkins dance in the slightest breeze, awaiting the arrival of their female counterparts in spring, when they will break open to release their life-giving pollen.

The joys of forest bathing among trees in winter include the grand vistas and natural artistry of branches outlined against the sky and the closeups of twig and bud. Many types of trees also bear fruit in winter—such as fleshy fruits like persimmons, which taste sweetest after a frost, or dry fruits such as maple samaras, whose winged seeds break free and whirligig in the wind like helicopter blades. The London plane trees—the city trees with whitened upper limbs—which grow not only in London, but also in Paris, Tokyo, New York,

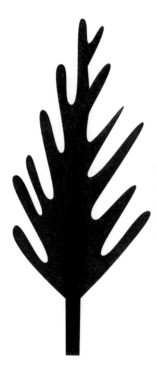

THE JOY OF FOREST BATHING

Washington, D.C., and many cities throughout the world— have hanging spherical clusters of tightly packed single-seeded fruits. When these round clusters break up in late winter and early spring winds, their tiny, dry fruits are revealed to be attached to feathery, pale-orange hairs that set them flying over river, parkland, and street.

You can also contemplate and interact with winter weeds during forest bathing walks. The dried stalks of goldenrods and asters bear fluffy, lighter-than-air seeds that set sail on winter breezes. Many other plants bear pods that open up to release silky high-flying seeds. You can help them fly by blowing on them; children especially love to do this.

Winter encounters with wildlife offer surprises and intrigue. There may not be as many bird species present in northern woods as in summer, but those that remain are easier to see in the leafless trees! A fox against a snowy field or a mink dining next to a creek can be thrilling winter sights. Following animal tracks in the snow and deciphering their clues are special pleasures of winter forest bathing walks. But not only animals make tracks. The naturalist Mary Holland posted a mystery photo on her blog that showed what looked like tiny tire tracks across the snow. She later revealed that it was made by a pine cone rolling downhill!

Of all the winter forest bathing pleasures, perhaps none is as powerful as the winter light, which is a joy to contemplate. Winter sunrises and sunsets are notoriously beautiful. A dome of bright blue sky above a fresh snowfall will stay in the memory for a long time, and winter clouds, whether puffy or wispy, can be swift-moving and stunningly beautiful. In far northern climes, a special treat is the nighttime display of aurora borealis, or northern lights.

If you tune into winter light, one of its greatest rewards is its expansion and return. If you live at any distance from the equator, when you spend time outdoors, you can't help but notice the increasing daylight after the winter solstice. You can keep track of the lengthening days by recording the times of sunrise and sunset between the winter solstice and the spring equinox.

Another joy of winter forest bathing is the way you feel when it's really cold. If you are bundled up and exploring a winter landscape, you are both part of the cold, outside world and also hunkered down in your own internal one, the inward and outer worlds connected by your own steamy breath. Perhaps you can build an outdoor fire and enjoy a hot cup of tea at the close of your forest bathing walk. If that's not an option, let thoughts of a warm fire and a hot beverage entice you homeward. Hibernation is an important and enjoyable part of winter and it is the incubating prelude to spring.

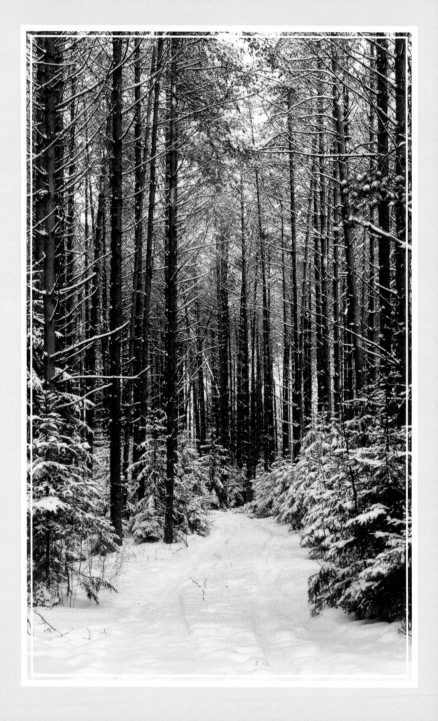

WINTER FOREST BATHING

🪷 Dress warmly

🪷 Tune in to winter landscapes and trees

🪷 Have fun with winter weeds
and flying seeds

🪷 Observe tracks and listen for winter
bird flocks

🪷 Witness winter light

🪷 Enjoy the fireside and a hot beverage

SPRING

If you have been forest bathing all winter, the joys of spring forest bathing will be magnified. The birth of spring in temperate regions resembles mammalian birth. Warm days coax the ice and snow to melt, the buds to swell, and the birds to sing. You can feel the earth awakening. Then a cold snap contracts the new season's advance. This process is repeated many times as spring is born.

When you forest bathe during spring you may find yourself in a perpetual state of radical amazement. The sights, sounds, and smells of the warming earth include newly flowing water, singing birds and frogs, carpets of colorful wildflowers, bursting tree buds, and the evocative scents of new growth. Each spring day brings forth new miracles. And it all happens very fast. You can see dramatic changes from day to day and sometimes from hour to hour.

You may want to play hooky or—better yet—take a weeklong vacation during budbreak, the time when the buds of trees and shrubs that were formed way back during the previous summer suddenly burst open, their scales falling to the ground as their hidden leaves and flowers emerge. Budbreak is a dynamic ephemeral process, and if you look away or bury yourself in work for even a week or two you will miss its annual magic.

Just as each tree has its own unique buds in winter, each tree has its own sequence and style during budbreak. Many Asian cherries, apples, peaches, pears, and magnolias planted in the U.K., Europe, North America, and other parts of the world produce early blooms, dazzling us with sudden clouds of pastels. The pointed buds of beech trees unfurl spirals of soft green leaves that initially point earthward like dancers' skirts. North American and Asian tulip-tree leaves burst from their buds pointing skyward, like babies' hands reaching for the clouds. Eventually, the leaves of both the beeches and tulip-trees will find a horizontal equilibrium, coming from opposite initial directions. Oak leaves emerge looking like tiny versions of their adult selves, except that they may be gold, red, or orange—almost autumnal in their palette. Along with the emergence of oak leaves, golden catkins of male oak flowers cover the tree and later carpet the ground, street, sidewalk, and your car. To the hurried person headed for work, or the allergy sufferer, a car covered with oak catkins may be problematic. To the forest bather, it's a source of radical amazement.

If you step back and look at a hill or mountainside in early spring, you will see that it is awash in tender golds, yellow-greens, reds, and oranges— but only during and immediately after budbreak. In no time at all, the forest settles into a uniform spring green, a green which then deepens toward summer. The New England poet Robert Frost wrote a poem entitled "Nothing Gold Can Stay,"

featuring the annual ephemera of bud break. Its first line is: "Nature's first green is gold, her hardest hue to hold."

I always feel a touch of melancholy when the golds of early spring settle into the greens of mid-spring and summer. Occasional melancholy seems to come with the territory when you really tune in to nature. This was something the foremost conservationist American president, Theodore Roosevelt, knew. He wrote: "There are no words that can tell the hidden spirit of the wilderness, that can reveal its mystery, its melancholy, and its charm."[6]

It may be that nothing gold can stay, but once the gold is gone from the leafing trees, high spring brings forth its own bountiful forest bathing rewards. The orchid called pink lady's slipper blooms near my home in May, and the wood thrush returns from its neo-tropical winter home to nest in our greening canopy. Its melodious birdsong, as if a serenade to the lady's slipper, sounds straight out of mythology, like Pan's flute.

High spring heralds the blooming of azaleas and the unfurling of lush fern fronds in wetlands. The wind whispers through newly formed leaves, and the first real and lasting warmth that is a prelude to summer begins. Awakened, we may feel like dancing in a glade or practicing yoga or tai chi under the trees.

SPRING FOREST BATHING

- Celebrate the sights, sounds, and smells of spring's awakening

- Observe budbreak and new growth in the trees

- Find carpets of wildflowers after snowmelt

- Enjoy newly flowing waters

- Witness migrating, returning, and nesting birds

- Listen for bird songs and frog choruses

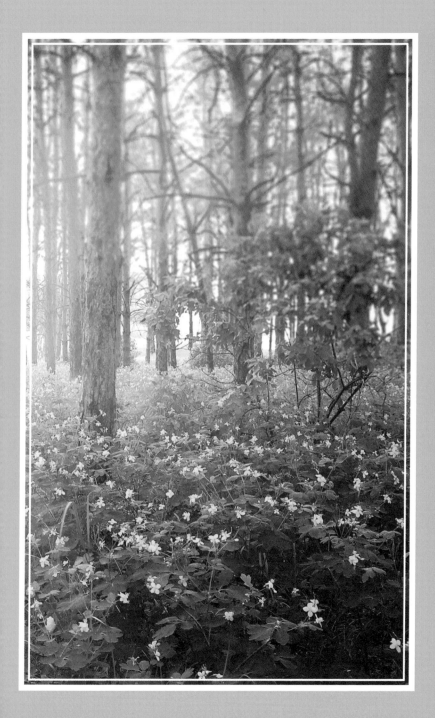

SUMMER

A farm can be a wonderful place for a summer forest bathing walk, offering sunny open fields and the cooling shade of woodlands and hedgerows. Sugar Moon Farm, near where I live, is my favorite place for forest bathing walks in the summertime. The landscape is a patchwork of rolling fields and rocky woodlands, lending itself to solitary communion with nature and guided forest bathing walks. I always start my walks on the farm in an open field near a spring that gives rise to a stream. In the summer, the field is filled with a colorful array of wildflowers. The flowers attract butterflies and one can get lost for hours watching the butterflies nectaring in their corollas. In my experience, no mental anguish can survive thirty seconds of butterfly watching.

The farmer who hays the land in the late spring leaves large barrel-shaped bales in the field throughout the summer season. Climbing on them during forest bathing walks affords child-like fun, as you inhale the fragrance of the hay. Sitting on a bale, you see a sweeping view of the fields, streams, and woodlands; lying back, you feel like you are soaring with the birds in the summer sky.

Forest bathing may feel most natural to you during the summer if it's something you've been unwittingly familiar with all your life. Lying back in the sand next to an

ocean, lake, pond, river, or stream—or simply reclining in a hammock in the backyard—those moments of nature immersion could be called forest bathing. Splashing barefoot or swimming in any natural body of water is forest bathing in the most literal sense. In Japan, forest bathing trails next to water, and especially waterfalls, are highly valued, not only for their sights and sounds but because the negative ions in the air around waterfalls are deemed especially healthful.

Many pleasures can lure you into a relaxed and joyful state during the summertime: flowing water, singing birds and musical insects, brilliant summer wildflowers, and verdant vistas. If you garden, hike, ride horseback, cycle, canoe, or kayak during the summer, you are afforded many occasions to pause and soak up the beauty and wonder of your surroundings. I love to kayak around an island in my city, where I can watch the river's tides ebb and flow and listen to the keening calls of ospreys as they cruise the water for fish. If you forest bathe from your kayak, you can paddle right up to the shoreline, getting close to brightly hued summer wildflowers leaning out over the water. Around my city's island, herons and egrets stand Zen-like in the river's shallows and turtles bask on every exposed log. As I paddle, dragonflies and damselflies surround my kayak. The city's historic buildings punctuate the horizon, giving the scene a surreal blend of the wild and the urban.

Summer is also the time to enjoy the fruits of forest and field: wild blackberries, strawberries, raspberries, cherries, blueberries and orchard fruits such as peaches, plums, and pears. If you are experienced enough with mushrooms to keep from getting into trouble with them, it can be a special summertime forest treat to find and gather them, and then bring them home to sauté in olive oil or butter. Gather mushrooms only if you are experienced with them!

Forest bathing at night is an especially magical experience in summer. Depending on where you live, the night air may be lit up by the flashing beams of fireflies or glowworms and infused with the sweet smells of honeysuckle under the moon. Crickets may sing deep into the night and owls may call with their mournful-sounding voices. If you live in the far north, it can be a special joy to savor the daylight until deep into the night.

The magic of the rising and setting suns and moons of summer and the sweetness of summer rains add to the forest bathing pleasures of the season. There's no need to stay indoors just because it's raining (except in threatening conditions). As Henry David Thoreau wrote: "It is worth the while to walk in wet weather; the earth and leaves are strewn with pearls."[7]

On every summer forest bathing walk, I ask someone
to read Mary Oliver's poem "The Summer Day" for its
powerful message and evocation of a forest bathing mood.
The poem celebrates blissful and idle wandering through
summer fields.

SUMMER FOREST BATHING

- Lie back and soar with the birds

- Inhale the fragrance of wildflowers, grasses, and hay

- Enjoy the deep cooling shade of the forest canopy

- Watch butterflies in fields and gardens

- Go barefoot and swim or splash in the water

- Canoe or kayak close to shore

- Eat summer berries, peaches, pears, and plums

- Enjoy the stars and moon in the night sky, and in the far north, the midnight sun

AUTUMN

The thought of an endless summer is seductive, yet who does not thrill just a bit to the first stirrings of autumn, despite the touch of melancholy they may bring? John Muir wrote: "Climb the mountains and get their good tidings. Nature's peace will flow into you as sunshine flows into trees. The winds will blow their own freshness into you, and the storms their energy, while cares will drop off like autumn leaves."[8]

Autumn is a time of fruitfulness and of letting go. The season brings crisp days and brilliant colors, ripe apples and grapes (and cider and wine), tumbling acorns, and the deepening chill and waning light that call us back to hearth and home. It is the time when migrating birds head to warmer climes and geese call out loudly and poignantly on their journeys.

Autumn, rich with childhood memories of summer endings and fall beginnings, pulls at our heartstrings. It is a wondrous time to forest bathe.

Autumn forest bathing walks give us much to contemplate and enjoy: glimpses of hurried squirrels storing food for the winter; wild, fleshy fruits ripening on crabapple trees, viburnums, grapevines, dogwoods, hawthorns, and hollies, and birds stocking up on them before migrating or

enduring the long cold winter; the abundance of dry fruits such as acorns and walnuts and the sounds they make as they fall to the forest floor; the color of autumn foliage; and the earthy smells of newly fallen leaves. In the British Isles, autumn is ushered in by late-blooming heather. Less well known are the other flowers of autumn, such as the asters, sunflowers, goldenrods, and autumn-blooming members of the mint and gentian families.

On autumn forest bathing walks, note all the colorful surprises around every bend in the trail. In addition to the visible abundance of the earth, the palpable feeling that change is in the air sparks a mixture of melancholy and excitement.

One of the forest bathing invitations that I like to give in autumn is to ask people to contemplate the word treasure as both a noun and a verb. I then ask participants to spend a few minutes exploring, looking for treasure or for something to treasure. When they come back to our sharing circle (described in chapter 1), they share the treasures they discovered. Some participants bring back something physical to share, like an acorn, an autumn leaf, or a partially decayed reddish-brown log (a surprisingly universal object of fascination). Others

describe less tangible treasures, such as a patch of sun piercing the autumn canopy or the sounds of late-season crickets. This invitation resonates well in autumn, perhaps because it's instinctive to take stock and add to our stores as the cold winter approaches, and perhaps because gratitude for riches is something we naturally contemplate as the year winds toward completion.

AUTUMN FOREST BATHING

- Revel in the sights, sounds, and earthy smells of the autumn forest

- Allow yourself both excitement and melancholy

- Enjoy apples, cider, grapes, and wine

- Gather autumn leaves, fall flowers, acorns, and other treasures

- Feel the excitement of migration and the pull of hearth and home

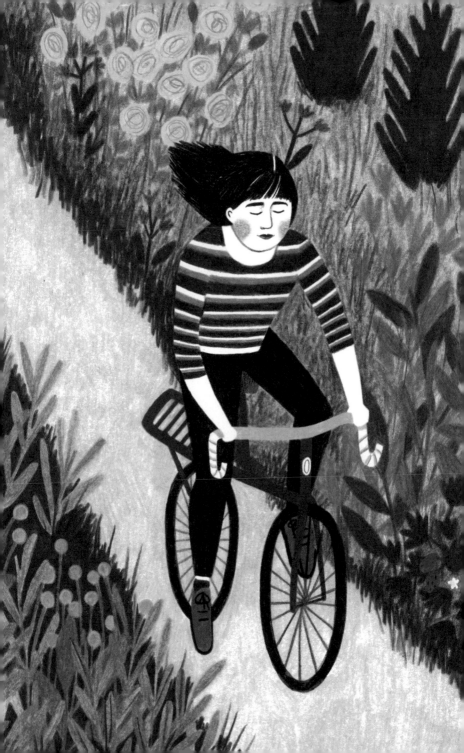

COMPATIBLE ACTIVITIES

MINDFULNESS PRACTICES

Forest bathing is a natural match for yoga, tai chi, meditation, and other mindfulness practices. Yoga postures and tai chi forms feel natural in the out-of-doors, and as you move slowly through your practice, your awareness of the poetry of place increases. You glimpse the forest through your legs in yoga's downward-facing dog pose; you may frame actual clouds in your hands when you form the tai chi motion "cloud hands." As your feet root themselves in the earth and your body moves slowly through the air, your connection to nature feels vital and vibrant. Meditation, too, can feel very natural outdoors.

On an autumn forest bathing walk focused on fragrant plants in Okutama, Japan—a two-hour train ride northwest of downtown Tokyo—our shinrin-yoku guide led us on a path that climbed steeply away from the forest therapy base and through a deciduous forest filled with fragrant flowers and shrubs. We frequently stopped to inhale their pleasing odors, and then moved on into groves of conifers. We paused to sit and lean back in long benches specially designed for sky-viewing. Farther up the trail, we were invited inside a charming forest tea house with a woodstove. After more than an hour of slow walking, we arrived at a wooden platform in the midst of a grove of towering Hinoki cypress trees.

A young woman was seated in the lotus position on a yoga mat on the platform as our small group arrived. She showed us mats rolled up on the ground under the trees and invited us to roll them out on the platform. For close to an hour she treated us to a restorative yoga practice as we breathed deeply of the Hinoki cypress-infused air with its proven immunity-boosting properties.

On another forest bathing walk, deep in the Japanese Alps north of Nagano, our guides stopped next to a pond that reflected nearby mountain peaks and handed us mats to place on the ground next to the water. Another yoga

instructor then guided us in a restorative yoga practice on the ground next to the pond with its mountain reflections.

You may have seen large groups practicing yoga or tai chi in one of the parks in your city. Both practices work well in city green spaces or in the countryside, almost everywhere in the world!

If you've struggled with meditating indoors, you may find it goes much better for you outside. In my case, I visit a large rock that lies at the foot of a rocky ledge on the edge of my favorite creek. I go so often that I have dubbed it the "Meditation Rock." Seated on this rock, with flowing water on three sides, ducks paddling past and herons stalking fish nearby, my brain quickly ceases all incessant chatter and I fully relax into a deeply peaceful state. I have another place that I often visit for woodland meditation, a place I call "Nana's Lap." Nana's Lap is a deep embracing crook at the base of a massive old tulip-tree. I have dubbed the tree "Nana" and her "lap" provides a place of comfort and safety. When you sing or chant while snuggled against the tree in Nana's Lap, you can feel the vibrations reverberating through the tree and your body. When the nearby trail isn't too populated, I often indulge in a few rounds of "Om."

If you can find a spot somewhere outdoors near where you live and visit it often for meditation, you may find—as I do—that it's easier to achieve a meditative state with the help of nature than indoors. Hammocks are also wonderful places to engage in horizontal meditation while watching the clouds and birds sail overhead.

Dancing is another powerful way to connect with nature on a forest bathing walk. It can be fun to dance when the wind is blowing, especially during autumn when the leaves are dancing on their downward spiral to the ground. I also like to dance in the woods and fields at night as the moon is rising.

If you forest bathe frequently—with or without the added practices of yoga, tai chi, meditation, or dance—you may find that forest bathing becomes such a natural part of your life that you're doing it everywhere, even as you walk to your car or perform a prosaic outdoor task. You can, like me, even forest bathe for a few quick minutes while you're taking out the trash. Let your heart thrill at the sight of reddish-brown fallen oak leaves and acorns lying on the ground. Listen for a familiar bird in a nearby tree, or scout out the resident wildlife. Be happy with whatever the sky has to offer in the way of sun, moon, cloud, wind, and weather. By the time you reach the trash cans, you may find yourself deep in reverie, soaking up enough nature-nourishment to tide you over for when you're back indoors at your computer.

EXERCISE

Hiking, walking, running, cycling, gardening, horseback riding, rock climbing, kayaking, canoeing, sailing, swimming, surfing, skiing, skating, snowshoeing, and any activity that you do out-of-doors is good for you! When you exercise in nature you draw oxygen and all the healthful properties of forest, mountain, ocean, moor, prairie, or desert air deep into your lungs.

If your time is limited, you may want to combine outdoor exercise and forest bathing. I often spend part of my time cycling or walking at an aerobic pace, and part of it forest bathing, either sitting in Nana's Lap or on the Meditation Rock or slowly moving through the woods, observing more than I would notice at a faster pace.

Mountain climbers, hill walkers, and woodland cyclists have many forest bathing moments naturally baked into their experience. During a challenging climb or bike ride, stopping to take in the beauty of the view is a reward for your hard work. As you marvel at the landscape, the clouds, the birds, and the movement of the air on your hillside or mountaintop, you may experience a feeling of oneness with your surroundings.

Walking your dog also affords many opportunities for forest bathing, especially if you take your cues from your pet. My fellow nature and forest therapy guide and mentor, Nadine Mazzola, and her dog, Juliet, lead forest bathing walks near Boston for people and their dogs. The people learn to increase their awareness and curiosity by following their dogs' leads.

WOODLAND ART AND WRITING

Walking in the woods helps the creative juices flow. Some of my best writing ideas occur to me when I'm out in nature. I confess that I've taken to jotting them down in the "Notes" feature on my iPhone. For anyone with a creative bent—and that's all of us—nature is a powerful muse.

Some people like to create art from nature itself. The British artist Andy Goldsworthy, who resides in Scotland, has brought the art of working directly with rocks, tides, and nature's ephemera to towering heights, creating dramatic outdoor artworks, some of which are destined to be washed away. But you don't have to be a creative genius to emulate some of Goldsworthy's techniques and enhance your relationship with nature. Working with stones, petals, leaves, feathers, winged seeds, sticks, earth, sand, and water you can create fairy houses, fleets of small boats, and all sorts of sculptures and creative works that will eventually be washed away by the rain or the tides. Such creations can be a rewarding part of any forest bathing walk.

Nature journaling is another natural ally of forest bathing. Drawing and writing about your surroundings and all you're witnessing in the moment increases your sensitivity toward the life around you. My artist friend, Tina Thieme

Brown, with whom I coauthored two books about a nearby mountain, encourages her students to experience drawing as "a way of seeing nature." Before drawing, she suggests that they look closely at how a leaf is built, explaining: "As your eye travels over the form and then the pencil follows, you become aware of the unique arrangement of veins and other details in each leaf. Sitting down with your sketchbook and focusing on a leaf takes on a meditative quality, giving yourself a few moments to block everything else out and let your pencil and eye follow the form."

Another creative friend, Kate Maynor, an art conservator at the Smithsonian American Art Museum, shared some wonderful nature journaling techniques with me that she learned in the field from John (Jack) Muir Laws, a well-known proponent of nature drawing and journaling who is based in California. During a three-hour session on a nearby island, Kate taught me how to combine drawing and writing on a sketchbook page along with data about

the weather and the setting to create a record of our
nature experience. We used three prompts ("I notice,
I wonder, It reminds me of") to focus and deepen our
observations about the plants and the setting. Tina and
Kate encouraged me to find a sketchbook to carry into
the woods with me. When I have the time, I bring it to the
Meditation Rock or Nana's Lap, where I draw and write
about what I am seeing.

Nature and poetry are of course a time-honored pair!
Many people love to write poems inspired by nature, and
haikus are especially suited to the forest. Song-writing may
also be inspired by time spent in nature.

SPECIAL CELEBRATIONS

You can enhance any outdoor celebration by weaving in one or more forest bathing elements.

By acknowledging the beauty of your surroundings with nature poetry, music, dance, or moments of silent reflection and awareness, you can add meaning and a sense of wonder to a wedding ceremony, anniversary, birthday party, or any special occasion. And there are days in the annual cycle that lend themselves to celebration of seasonal change: the first day of each season (the winter and summer solstices and the spring and fall equinoxes) and the "cross-quarter" days in between: May Day or Beltane, Lammas Day or Lughnasadh, Halloween, All Saint's Day or Samhain, and Candlemas, Imbolg (Imbolc) or Groundhog Day. Children enjoy celebrating the seasonal holidays with festive gatherings and playful rituals.

In addition to formal ceremonial celebrations of nature, there are the moments in nature that are integral to your own personal life. Almost every experience of deep meaning in my life has been steeped in natural beauty. I mentioned some of my childhood memories in my introduction, and I'm happy to say that those indelible experiences in nature have extended into adulthood.

As for adolescence, mine occurred before the advent of shopping malls and social media, and most of the times I associate with young romance are steeped in nature lore. I wish it would be so for the young people of today and tomorrow.

Today, my personal, social, and professional lives all revolve around nature. I have my moments of waldeinsamkeit, when I am deep in solitary nature reverie. And I meet many people in the woods—both chance meetings with friends and strangers who become friends—as well as on scheduled nature and forest bathing walks. And I write books about nature, which is usually what I'm doing when I'm inside at the computer or on warm days outside with laptop on the picnic table.

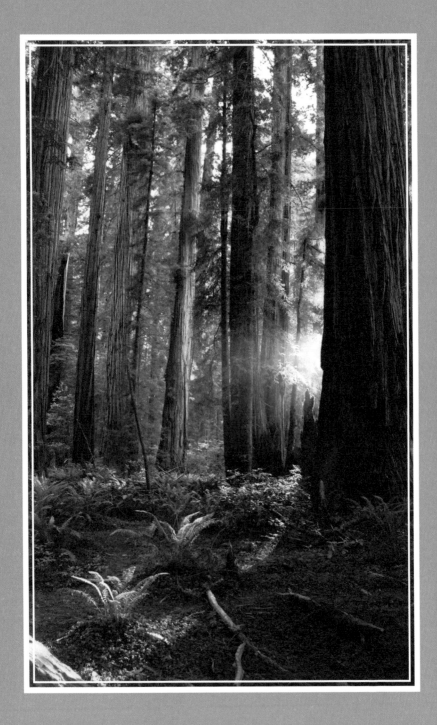

COMPATIBLE ACTIVITIES

- 🪷 Yoga, tai chi, and meditation
- 🪷 Ephemeral creations, sketching, journaling, poetry, and song-writing
- 🪷 Outdoor exercise
- 🪷 Special celebrations, formal and informal

FOREST BATHING AS THERAPY FOR ALL AGES

Forest bathing can be a joyful and health-enhancing practice at any age. Children need little prompting to connect with nature—just the opportunity and freedom to explore.

I never cease to be amazed by the way children respond when they have a little freedom in a wild or semiwild place. They race through the woods, climb on any available rock or tree, and come up with wildly imaginative games and theatrics. If you are in their presence, I suggest simply following their lead and participating on their terms—or staying on the sidelines and letting them go! Ordinarily, the only prompting I give children when I'm in the woods is to introduce something—a game of Pooh Sticks, or the fun of collecting the winged seeds called samaras and dropping them from a footbridge to watch them slowly whirligig their way to the water below.

If you would like to do something more organized with children, focus on the whimsical and magical. Treasure hunts always appeal to them and they love woodland games and imaginative play in which they pretend to be forest creatures. Children also enjoy crafting fairy houses and ephemeral art from sticks, stones, leaves, and other found objects in nature.

If children have grown up in a totally urban environment with little green space, they may need some reassurance to feel safe and comfortable in a wild or semiwild area. Take your cues from them and provide the reassurance they need to feel free to explore. A setting close to home with some familiarity will probably work best for nature exploration, provided the environment is safe.

TEENAGERS

I have been amazed at how easily and brilliantly teenagers have taken to forest bathing. I was asked by the teachers of a global ecology program to lead two forest bathing walks for high school freshmen on a nearby mountain on consecutive days in the spring. When we got to the summit of the mountain, the first group of twenty-five students draped themselves over the rocks in prone and supine positions, looking more at home than mountain lions! They responded to every invitation and took to the talking stick with no discomfort, sharing personal nature reflections easily and naturally.

The second group of forty students had a harder time getting in the forest bathing groove. It was a cold and windy day and many of them weren't adequately dressed for the weather. Several of the boys balked at the talking stick, openly making fun of it as it was passed to them. However, even the most skeptical boys were quiet while their classmates shared their reflections and after a time everyone grew comfortable with the invitations and sharing rounds. By the time we left the mountain summit, they all seemed relaxed and happy.

Leading walks for teenagers was a moving experience. During those walks, I realized how stressed teenagers are in our uncertain and over-scheduled world, with so much of their time spent online and engaged with social media. It can be a release for them to unplug and get away from the classroom in a setting of natural beauty where all that is expected of them is to enjoy their surroundings and share their experiences with their peers!

SENIOR CITIZENS WITH LIMITED MOBILITY

At the other end of the age spectrum, forest bathing is a great comfort and joy for elder people. All around the world, we should lobby for wheelchair-accessible and walker-friendly forest bathing trails near hospitals and retirement homes. When my father-in-law was suffering from Alzheimer's disease, he took great joy in visiting the trees in his wheelchair, even on a bitterly cold day. I wheeled the chair right up to the tree trunks so that he could touch the bark with gloved hands. I crushed handfuls of pine and fir foliage so that he could inhale their delightful and healthful fragrances.

People approaching the end of life can find comfort in feeling part of nature. If you've lived to a ripe old age, you've undoubtedly gained some wisdom about the value of the present moment and life's simplest pleasures. Feeling like you are part of the web of being can bring you out of any isolation you may feel and into the light of nature's joys.

RECOVERING FROM ILLNESS AND SURGERY

I hear from many doctors and therapists who want to employ forest bathing techniques to help people recovering from illness and surgery and to assist those coping with depression, addiction, chronic pain, and many types of disabilities. According to Dr. Suzanne Bartlett Hackenmiller, who is both a physician and a certified forest therapy guide, studies show that hospital patients with access to garden views and garden walks tend to recover more quickly. Now that we have accrued so much data showing the physical, mental, and emotional benefits of time spent in nature, we can employ this knowledge in many creative ways to facilitate healing and recovery. Some doctors are now writing "Nature" on their medical prescription pads and even suggesting that patients visit specific parks near their homes. This is only the beginning when it comes to integrating forest bathing into our health systems.

GRIEF AND PROBLEM SOLVING

Forest bathing helps with problem solving and coping with grief. When you face a problem with no easy solution, the best thing you can often do is to walk in the woods. Try to clear your mind of ruminative thought, which is easily done in the presence of flowing water and trees. You may be amazed at how often the guidance you need will seem to materialize from the forest air. I trust to a bit of mysticism here, and I think we must all admit how little we really know about the ways of trees and their forest connections. We are learning that trees and other plants communicate with each other through volatile chemicals emitted into the air and through fungal networks connecting them to each other through their roots. They share information with each other that protects them from invasive pests and pathogens and they even share nutrients underground. Perhaps trees have a little extra wisdom and nurturing to share with us too.

Nature can be a great comfort when you are facing grievous loss, gently easing your sorrows with tender beauty. I have been in the presence of people in the forest who have felt the spirits of departed loved ones visit them through birds, trees, and other wild living things. Surrendering to these mysteries brings comfort and the certainty that, while many things may remain beyond our conscious understanding, we are not alone.

FOREST BATHING FOR ALL AGES

- Forest bathing with children: let them lead or focus group activities on the whimsical and magical

- Forest bathing with teenagers: they welcome the relief from stress

- Forest bathing with elder people: wheelchairs can be rolled right up to the trees and flowers on accessible trails

- Forest bathing helps with healing from disease, surgery, depression, and addiction

- Nature can help with problem solving and healing from grief

FOREST TENDING

When we consider a natural area near us to be a "wild home," it stands to reason that the desire to protect it from harm goes with the territory. Doing so may include everything from picking up trash and removing invasive plants, to becoming an activist in order to prevent any sort of destructive projects or plans. Have you heard the conservation adage "We protect what we love?"

I must admit that, probably like most of you, I never really enjoyed carrying an empty garbage bag with me into the woods and hauling it out full of trash. But it became a much less onerous task when my forest bathing mentor, Amos Clifford, who is founder of the Association of Nature and Forest Therapy Guides and Programs and author of *Your Guide to Forest Bathing*, reframed it for me. Amos calls picking up trash, removing invasives, and any sort of nature caretaking "wild tending." He was inspired by the wisdom of the Native American tribes in his home state of California. They have tended their land for centuries, long before European contact. Tending is such a nurturing-sounding concept that it helped me to enjoy doing things that, although necessary, lack intrinsic appeal. When I am "tending" the Meditation Rock, which is located at a bend in a creek and is a catch-all for plastic bottles flowing downstream, it's a much more loving task than mere "trash collection."

Tending our own beloved places sensitizes us to the stewardship needs of places beyond our horizons. For example, the creek that flows through my wild home has a life upstream, where its tributaries spring from the earth, and downstream, where it flows into a large river and bay. The wood thrush, who sings its flute-like song as it nests in our woods each spring, requires a wild winter home in the tropics and safe passage for migration. If the trees in its winter home are destroyed, or climate change interferes with the timing of food sources along its migratory path, the bird will not survive and return to nest in these temperate woods in the spring.

When you move very slowly through the woods on forest bathing walks you become attuned to all the life around you in an open-hearted way. A heart open to nature is a heart that yearns for careful stewardship of all life on earth. When we become tenders of our own wild homes, we become, by extension, tenders of the wider world.

Incidentally, Amos recommends that we don't "tend" every time we visit our familiar places. He told me about an experience he had in a redwood forest near his home: "After a few years of collecting trash and other tending every time I visited, I was resting against a tree one day

when I 'heard' it, and the other nearby trees, tell me that they appreciated my work tending them, but they wanted me to come sometimes for simple enjoyment and to just keep them company. When I started doing that, it really shifted my relationship. I felt that I started seeing more of the forest in different ways."

We need not tend every time we go to the woods, lest we forget that pure enjoyment of natural beauty is our birthright. As sensitive stewards, it's important that we let go of any guilt we may harbor in order to enjoy full communion with nature on forest bathing walks. When we surrender to the beauty of a time and place, we may be happily surprised to discover how gracefully nature welcomes us back into her embrace, even after years of absence. When we're in the forest, we breathe, we belong.

As forest bathers reconnecting with nature for our own health and happiness, we become part of a global community that is celebrating and nurturing the earth.

YOUR FOREST BATHING JOURNEY

Do you now feel ready to begin your forest bathing journey, or—perhaps more aptly—resume your explorations of the natural world at a slower pace with all of your senses engaged?

I hope Lieke and I have convinced you that you need not travel to the Japanese Alps to experience the mysterious joys of forest bathing. Just step outside your door and open your heart and mind to the world of natural wonders that awaits you. From the clouds above to the wildflowers pushing through the cracks in the sidewalk, nature is ready to welcome you wherever you live.

Happy Forest Bathing!

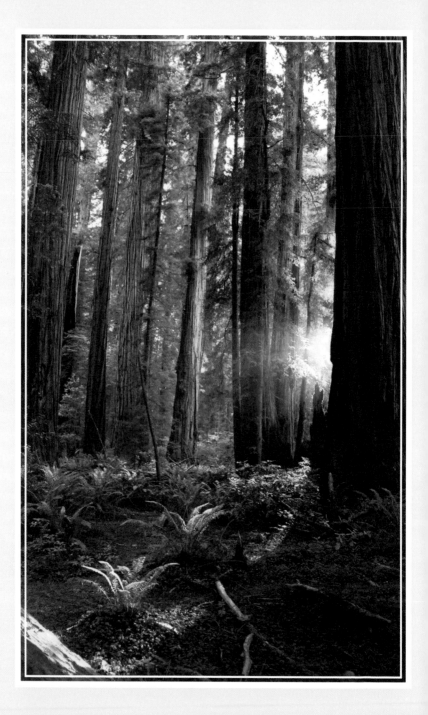

FOREST
TENDING

- 🌿 Tend your "wild home" by picking up trash and addressing other stewardship needs

- 🌿 Advocate for healthy forest policies

- 🌿 Take what action you can and then let go of guilt to fully enjoy the beauty and wonder of your time in nature

- 🌿 Become part of a community of environmental stewards

- 🌿 Open your heart to the beauty of your home forest or natural area as well as the wider world

RESOURCES & NOTES

ACKNOWLEDGMENTS

Thank you to my mentors, colleagues, and friends in the forest bathing world, with particular thanks to Kazuhiro Kouriki, Tounoki Akira, Dr. Yoshifumi Miyazaki and his research team in Japan, Amos Clifford, Michele Lott, Michael Stusser, Jamie Trost, Meg Mizutani, Nadine Mazzola, Clare Kelley, Dana Galinsky-Malaguti, Dr. Suzanne Bartlett Hackenmiller, and all my buddies in ANFT Cohort Six in the US and Canada. Special thanks to Andrea Brown, Shawn Walker, and my loyal, astute, and loving readers: Jim, Sophie, and Jesse Choukas-Bradley, Michael Choukas Jr., Ellie Anderson, Hill Anderson, Carole Bergmann, Tina Thieme Brown, Terrie Daniels, Kate Maynor, and Susan Austin Roth. Thank you to Rage Kindelsperger, editorial director at Rock Point, for her creative vision, and Keyla Hernández and Heather Rodino for their thoughtful editing. Thank you to my literary agent, Marilyn Allen, for her inspiration and advice. And many thanks to Lieke van der Vorst for creating her sensitive and evocative art.

RESOURCES & RECOMMENDED READING

Carson, Rachel. *The Sense of Wonder.* New York: HarperCollins, 1998. Originally published in 1965.

Choukas-Bradley, Melanie. *A Year in Rock Creek Park: The Wild, Wooded Heart of Washington, DC.* Photographs by Susan Austin Roth. Staunton, VA: George F. Thompson Publishing, 2014.

Clifford, Amos. *Your Guide to Forest Bathing: Experience the Healing Power of Nature.* Newburyport, MA: Conari, 2018.

Laws, John Muir. *The Laws Guide to Nature Drawing and Journaling.* Berkeley: Heyday, 2016.

Li, Qing. *Forest Bathing: How Trees Can Help You Find Health and Happiness.* New York: Viking, 2018.

Miyazaki, Yoshifumi. *Shinrin Yoku: The Japanese Art of Forest Bathing.* Portland, OR: Timber Press, 2018.

Oliver, Mary. *Devotions—The Selected Poems of Mary Oliver*. New York: Penguin Press, 2017.

Smiley, Nina, and David Harp. *Mindfulness in Nature*. Hatherleigh Press, 2017.

Thoreau, Henry David. *Walden*. New York: Book-of-the-Month Club, 1996. Originally published in 1854.

Williams, Florence. *The Nature Fix*. New York: W.W. Norton & Company, 2017.

Wohlleben, Peter. *The Hidden Life of Trees: What They Feel, How They Communicate*. Translated by Jane Billinghurst. Vancouver/Berkeley: Greystone Books, 2015.

ABOUT THE AUTHOR

Melanie Choukas-Bradley grew up in rural Vermont wandering the woods and fields and stealing icy sap from the sugar maple buckets lining her dirt road in the early spring. She and her husband, Jim, currently live in metropolitan Washington, D.C. They have two adult children. Melanie writes books and leads forest bathing walks, nature field trips, and tree tours on foot and via bicycle and kayak. She is the award-winning author of *A Year in Rock Creek Park*, *City of Trees*, and two books about Sugarloaf Mountain, Maryland. Melanie is a nature and forest therapy guide with certification from the Association of Nature and Forest Therapy Guides and Programs. In October 2017, she traveled throughout Japan on a forest bathing trip.

ABOUT THE ILLUSTRATOR

Illustrator Lieke van der Vorst grew up in Kaatsheuvel, a very small town, in The Netherlands. Every summer her parents would pack their De Waard tent and drive thirteen hours to Provence, France, to camp among the lavender fields. It was these trips in nature that influenced her life and work the most. Being kind to animals and the environment soon became an important part of her vision. She uses her illustrations to make a positive impact on the world and to keep people honest and humble. She practices green living as much as possible.

Follow her on Instagram @liekevandervorst

ENDNOTES

[1] John Muir, *My First Summer in the Sierra* (St. Louis, Mo: J. Missouri, 2018), 106. Originally published 1911. Passage written on July 31, 1869.

[2] Mary Oliver, *Devotions: The Selected Poems of Mary Oliver* (New York: Penguin Press, 2017), 347 ("Wild Geese") and 123 ("When I Am Among the Trees").

[3] Wendell Berry, *The Selected Poems of Wendell Berry* (Berkeley: Counterpoint, 1998), 30 ("The Peace of Wild Things").

[4] John Muir, *John of the Mountains: The Unpublished Journals of John Muir* (1938), edited by Linnie Marsh Wolfe (Madison: University of Wisconsin Press, 1938, republished 1979), 439.

[5] John Muir, "Mormon Lilies," *San Francisco Daily Evening Bulletin*, July 19, 1877; reprinted in Steep Trails (1918), chapter 9.

[6] Theodore Roosevelt, *African Game Trails*. (Arcadia Press, 2017), 5. Originally published in 1910.

[7] Henry David Thoreau, *The Journal 1837–1853* (New York: New York Review of Books, 2009), 220.

[8] John Muir, *Our National Parks* (Boston and New York: Houghton Mifflin, and Cambridge: The Riverside Press, 1901).